Paul Hill

EADWEARD
MUYBRIDGE

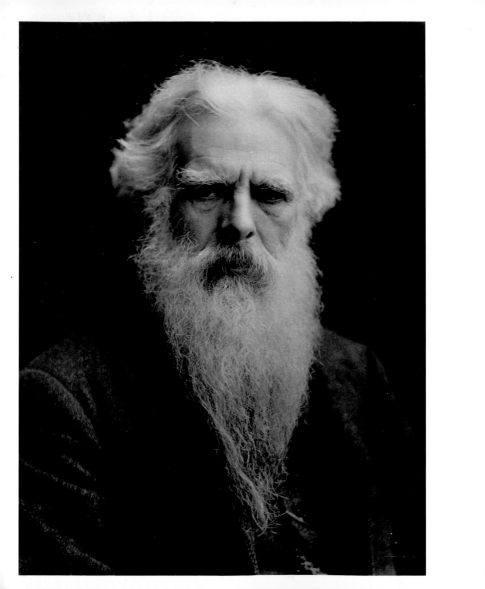

Among the most important names associated with the history of early photography is that of Eadweard Muybridge. His photographs of the 1870s and 1880s changed the way in which people understood animal and human movement. The sequences of images in the huge volume entitled *Animal Locomotion* (1884–7), depicting men, women, children, animals and birds in a variety of attitudes, made a great impact on artists and scientists alike. For the first time, the artist could see how to depict a horse, for example, at a particular stage in its movement, whether trotting, galloping or cantering, and could also take advantage of Muybridge's foreshortened views. The scientist interested in the mechanics of equine motion, or the positions of a bird's wings in progressive stages during its flight, would have the data necessary for further research. It is not surprising that in December 1878, the eminent French scientist Étienne-Jules Marey wrote to the Editor of *La Nature*, Gaston Tissandier, who had published some of Muybridge's early motion photographs undertaken at the Palo Alto stock farm, describing himself as 'lost in admiration over the instantaneous photographs of Mr Muybridge'.

The magic of Muybridge's work has never faded. There is a sense of the pioneer spirit about it; a voyage of discovery that awakens something in all of us. When we look at a Muybridge motion photograph for the first time, we can be forgiven for thinking that we have seen it somewhere before. Muybridge's photographs are so imbedded in our minds that they have become symbolic of Western culture.

Muybridge came to photography late in his career. He was born Edward James Muggeridge in Kingston upon Thames in 1830. Twenty-one years later, he sailed to America to 'make a name for himself', leaving behind a large family overseen by the matriarch of their merchant business, his grandmother Susannah

Norman Smith. Working for a while as a commission merchant for a bookbinding company in New York, he picked up some of the business skills that were later to enable him to promote his fine landscape photographs. It was also in these early years that Muybridge came into contact with photographers and their work, in particular Silas T. Selleck, whose experiments in daguerreotypy kindled a keen interest in the young Englishman.

Following in the wake of Selleck and others, Muybridge headed west to San Francisco, arriving in 1855, where he set up a bookstore at 113 Montgomery Street. He did modestly well for himself in his new business. It was here that his name began its curious transformation from Muggeridge to Muybridge; at this time, his books were stamped with the name E.J. Muygridge.

By 1859, Muybridge had seen the work of contemporary landscape photographers such as Charles L. Weed, Robert Vance and Carleton Watkins. Weed had taken some of the earliest views of the Yosemite Valley, and it was to this great landscape that Muybridge turned his attention with his new camera and equipment.

Following a bad stagecoach crash, sustained whilst travelling across America in the summer of 1860, Muybridge spent the years 1860–65 recovering back at home in England. Although digressing briefly to invent a remarkable washing machine, he maintained his interest in photography. He spent much time with a local photographer and friend, Arthur Brown, who had been experimenting with chemicals to obtain better definition in the medium tones, and their discussions must have turned to the matter of instantaneous photography and the chemical mixtures required to achieve it. It would be a while, however, before the instantaneous photograph was to become an obsession.

Returning to California, Muybridge began producing commercial photographs, most of which were cards for the stereoscope, a popular parlour toy. Muybridge the photographer had arrived. His years in Kingston had influenced his final name-change. The town's famous monument, a stone upon which seven Saxon kings were crowned, had been inaugurated in 1850 and on its plinth was inscribed the name of each king. He took for himself the spelling of one of these names – Eadweard. He arrived in San Francisco with cameras, money and a 'Flying Studio', which he called Helios. The stage was set for one of the most eventful careers in the history of photography.

Between the years 1867 and 1873, Helios was extraordinarily productive. Muybridge busied himself with views of San Francisco, based with Selleck at 415 Montgomery Street in the Cosmopolitan Gallery of Photographic Art. His pseudonym became well known, and the quality of his landscapes further enhanced his reputation. Thousands of stereographs were taken of the city in these years. In these pictures, Muybridge exhibits a clear appreciation of atmosphere and landscape, characterized by the effects of moon and sunlight, the textures of trees and plants, and in particular, an obsession with clouds. His compositional skills were exemplified by his invention of a technique known as 'Sky Shade', a method of holding back the exposure of the sky area in his negatives to prevent a washed-out appearance whilst giving fuller exposure to other areas in the picture.

Although the city was exhaustively photographed by Muybridge, it was his photographs of its environs that brought him new prestige. The equipment that a photographer of his day had to take with him on such journeys was unwieldy and cumbersome. Furthermore, the terrain over which it was carried was difficult

in the extreme. Muybridge would pack chemicals, glass plates, cameras and firearms for his trips. His Yosemite Valley work stands in contrast to that of his predecessors. Weed and Watkins were both accomplished photographers of the valley's scenery and Weed's first visit preceded Muybridge's by at least six years. The difference exists in the vantage points that Muybridge chose. He was extraordinarily energetic, seeking out peculiar spots and taking the type of picture that repays close examination. There is often something unusual happening in his carefully composed landscapes. Lone figures may be seen in the middle ground, dwarfed by the towering valley around them. In the foreground is often a tangled complexity of twisted tree roots or rocks, and a cloud study is frequently brought into the composition. Muybridge returned to the valley many times over the next ten years or so, producing better work each time.

The reaction of the press to the Yosemite pictures was favourable, the critics noting an artistry in photography not seen before. Muybridge was not only providing himself with a comfortable living, but was moving in all the right circles. His views were bought by the culture-hungry, wealthy residents of the city, and it was here that he made a contact that would lead to an extraordinarily productive partnership.

Governor Leland Stanford of California was a wealthy man. He was one of the 'Big Four' railroad barons of the era, responsible in his capacity as President of the Central Pacific Railroad for the huge effort that resulted, in 1869, in the joining of the Central Pacific with the Union Pacific Railroad in Utah. Stanford commissioned Muybridge to photograph the Central Pacific Railroad. Many of the views, such as 'Tunnel No.1, the first bored on the

CPRR, looking East' may seem unremarkable to us now, but to the first travellers on these pioneer railways, they would have been highly evocative.

The years between 1867 and 1873 were heady times. Commission followed commission, and US government departments frequently sought his skills. Muybridge based himself at Woodwards Gardens in San Francisco, a classic Victorian amusement park with rides, a menagerie and a gallery at which he exhibited. His travels took him to Alaska, where he photographed aspects of this newly acquired territory on behalf of the US War Department. Some of his photographs of the natives of Sitka remain a powerful reminder of the fate of these people, and Muybridge, although essentially a landscape photographer, was not slow to include studies of villagers in his work. Following this commission, he photographically surveyed the Farallon Islands and the lighthouses of the Pacific Coast. Between 1872 and 1873, he travelled to the lava beds of northern California, where he photographed the landscape and some of the people involved in the conflagration known as the Modoc War, where, under the notorious chief Captain Jack, the Indians were stubbornly resisting white man's law.

Despite these worthy commissions, Muybridge still had enough energy to concentrate on private commercial photography, which he promoted from several different San Francisco galleries, such as Selleck's Cosmopolitan Gallery of Photographic Art, the studios of the Nahl brothers, and Bradley and Rulofson's gallery on Montgomery Street. The majority of the work in this period comes in the form of stereographic views of San Francisco and its environs, with some beautiful large-plate work. In 1872–3 Bradley and Rulofson produced *Scenery of the Yosemite Valley and Mariposa Grove*, comprising hundreds of exquisite views of the valley and its surroundings, which many people acknowledged as

surpassing Muybridge's previous work there in terms of compositional integrity and feeling. The photographer became – perhaps unwittingly – the focus of attention between feuding galleries in San Francisco. With *Scenery of the Yosemite Valley* netting $20,000 in pre-subscriptions, it is easy to see why.

In 1872 an argument within horse-racing circles, which had been ongoing for as long as anyone could remember, came to a head, fuelled by increasing press interest. Did a trotting horse have all four feet off the ground at any stage of its movement? Governor Stanford, who was a keen horse owner himself, soon became involved in the controversy, firmly believing that a horse did indeed 'fly' at some stages during the trot. The issue became known as 'Unsupported Transit' and Stanford asked Muybridge to solve it with an instantaneous photograph. A great deal of money would rest on the results. Wagers ran into the thousands of dollars across the country, and papers such as the *Alta California* and the *New York Spirit of the Times* were responsible for whipping up a frenzy of publicity.

The subject of the great experiment was Occident, Stanford's champion trotter, soon to become one of the most celebrated horses in America. One day in May at the Union Park Racecourse in Sacramento, Occident trotted past the camera, pulling a sulky and its driver, while Muybridge took his instantaneous picture. But it was not that simple. He had to come up with a way of exposing a wet collodion plate quickly enough to get a clear image. By manipulating the chemicals available to him, however, and constructing a fast shutter device, he was able to produce pictures that, although little more than silhouettes, proved the phenomenon of Unsupported Transit. Some doubted that Muybridge had genuinely managed to achieve it. Retouching of photographs was part of a photographer's art and Muybridge was no exception. Many claimed he had

'got-up' the results. However, he made a public statement that anyone could come and view the negatives in his gallery. Sadly, these early conclusive photographs have not survived.

The Sacramento experiment was just the beginning. Stanford's curiosity and his interest in horse breeding led him to purchase a stock farm at Palo Alto. He wished to find out whether certain horses moved more efficiently than others, and if these characteristics could be nurtured by good breeding. Muybridge's instantaneous photographs were to help him in his quest to study his horses in motion, and the science of Animal Locomotion was taking a new turn. More single photographs were taken of Occident in 1873, 1876 and 1877. The elaborate camera shed constructed at the side of the race track at Palo Alto was ready by 1877 for the first pictures of the great analytical project known as the 'Series' photographs. But before he undertook the work for which he is now principally remembered, Muybridge had to deal with a personal tragedy that demanded his full attention.

Flora Shallcross Stone was an attractive divorcee in her early twenties, whom Muybridge had met at the Nahl gallery in San Francisco. They were an odd match and shared little in common, but Flora's first marriage to businessman Lucius Stone had been so unhappy that the love Muybridge offered must have seemed very welcome. Sadly for Muybridge and Flora, their own marriage ended in tragedy. Flora became involved with another Englishman, Major Harry Larkyns, dramatic critic for the *San Francisco Post*. Larkyns was a socialite and popular with the ladies. His mistake was not so much in sweeping Flora off her feet while Muybridge was half way up a mountain in Yosemite, but in the careless and public way in which he did it. They were often seen in each other's

company at the theatre. Worse still, Muybridge caught the lovers together at least once and confronted the major, forbidding the liaison to continue. Later, Muybridge warned Larkyns that he would kill him.

On 15 April 1874, Flora gave birth to a child, Floredo Helios Muybridge. Larkyns was convinced the boy was his. Muybridge's suspicions were aroused by a meeting with Flora's nurse, Susan Smith, who at first denied the affair, but had in fact acted as a messenger for the lovers. She let this slip after some provocation and Muybridge was crippled with grief. Immediately, he resolved to carry out his threat and headed back to the Bradley and Rulofson gallery, where he fetched a pistol and passing William Rulofson declared 'One of us will be shot!' Larkyns wisely changed jobs and moved out of town. It didn't help him much. Muybridge found his prey at the Yellow Jacket Mine ranch house near Calistoga. Stepping out of the darkness, he shot him dead on his doorstep. The last words Larkyns heard were 'My name is Muybridge and I have a message for you from my wife.'

Muybridge spent the rest of the year and the winter of 1874–5 in Napa County Jail, awaiting the trial, which took place in February. Representing him in this showpiece trial was William Wirt Pendegast, an expert lawyer. Press coverage was extensive and public opinion was in favour of Muybridge. Pendegast would have to use it well, since the original plea of insanity was not working, because Muybridge did not like the accusation. When Rulofson gave evidence regarding Muybridge's state of mind, he cited the photographs of Muybridge dangling over the cliffs of Yosemite as evidence of a man out of his mind. Muybridge never forgave him. Pendegast brought the argument away from the insanity plea and went straight for the jugular, arguing that the law was weak and should have punished the seducer. Muybridge had only done what any decent man

would do. The gamble paid off and the jury bought this moving argument. Muybridge was acquitted. When the verdict was announced, he fell to the floor. The rollercoaster ride had ended, and the recovery could now begin.

His return was emphatic. In 1875, Muybridge travelled to South America to undertake a project that he had planned while in prison. He sailed alone to Panama, leaving his troubles behind him. His pictures of Panama City, of Antigua in Guatemala and of the ruined colonial churches of South America, are well known for their beauty. Although he made money out of the tour, his best volumes were bound in an exquisite album entitled *The Pacific Coast of Central America and Mexico; The Isthmus of Panama; Guatemala; and The Cultivation and Shipment of Coffee. Illustrated by Muybridge.* (San Francisco, 1876) and given to the newly bereaved wife of William Pendegast, who had died in February, and to institutions such as the Pacific Mail Steamship Company, which had helped him on his trip. On his return to America, distressing news greeted him: Flora had died at the age of only 24. It is difficult to know just what Muybridge must have felt about this, but the event will surely have revived the pain he had tried to overcome with his South American trip.

Two main projects now concerned him – a panoramic view of San Francisco and a continuance of his work with Governor Stanford at the Palo Alto Stock Farm. Throughout the 1860s and 1870s, Muybridge had produced some understated efforts at panoramic views of the city. Now, in January 1877, he set himself up in the Hopkins Tower, the residence of railroad baron Mark Hopkins, which was an extraordinary building commanding an impressive view of San Francisco. Using 8 x 10 inch plates, he produced a panorama of eleven panels measuring 7 feet in total. Later that year, he sold editions of the work from Morse's Gallery in

Montgomery Street for a price of $10, accompanied by a key of the individual buildings. It became a collector's item. Unsatisfied, however, he returned to the tower in November with a new set of equipment and using 18 x 22 inch plates produced a huge version of the panorama measuring 17 feet in length and comprising thirteen panels of 20 x 16 inches each.

Sadly, a fire at Morse's gallery consumed the negatives of the 1877 panorama and all of the negatives from the trip to South America. But none of this stopped Muybridge from perfecting his art. In April 1878, he set out again to climb the tower on Nob Hill and took a panorama of breathtaking quality on mammoth plates as he had done before. This panorama survives today in nine separate copies around the world. Close inspection of each panel shows a depth and quality to the exposures that reminds us that Muybridge, working in the wet collodion method, was a master chemist. His fast-exposure experiments were rewarding him well in these landscape photographs.

The year 1878 was an intense one. Back at the Palo Alto Stock Farm, twelve Scoville cameras with double Dalmeyer lenses awaited him for the 'Series' photographs. Stanford's horses Occident and Abe Edgington were among the first subjects to pass the camera shed. A method had to be devised to set off the camera shutters in sequence. At first, the horse took its own picture, breaking threads attached to the powerful shutters in front of the lenses. This proved unsatisfactory, however, and another, more elaborate method was designed to allow the wheels of a sulky to complete an electric circuit when they passed over wires on the ground attached to electromagnets holding up the shutters. This was better, but could only work with a horse and trap. Finally, an automatic timer mechanism was constructed, which

released each of the camera shutters in sequence, allowing for instantaneous photographs of a variety of subjects.

These experiments were warmly greeted by the international press, and Muybridge was so proud of the way in which he had solved the problems that his pictures of the equipment and machinery formed an important part of the publications resulting from the work. Single cards showing six, eight and twelve positions of a horse in motion were among the first photographs released. Further images were published around the world in scientific journals. Work continued throughout 1879 and then fitfully until 1881. Muybridge published the results, including pictures of his apparatus, in a work entitled *The Attitudes of Animals in Motion* in 1881. Many pictures were prepared as lantern slides for lecture tours of America and Europe on the subject of Animal Locomotion. These lectures cemented Muybridge's reputation, and it is as lantern slides that many of his pictures survive today.

As well as using a biunial lantern to show slides of his pictures alongside erroneous artistic representations of equine motion, Muybridge brought another machine to his lectures – a zoopraxiscope. This extraordinary machine amazed its first audience at Mayfield Grange, Palo Alto in 1879. It consisted of a lantern house and a lens between which was placed a mechanism for a spinning glass disc, mounted next to a counter-rotating slotted shutter. Around the edge of the disc were painted silhouettes of individual stages of motion from one of the subjects of the Palo Alto experiments – horses, cows, athletes, etc. The resulting effect on the screen on that first day was a life-size image of Occident running across the wall in real time. To those who saw it, the motion picture was born in the autumn of 1879.

Muybridge undertook successful tours to Paris and London in 1881 and 1882 respectively. At home, Stanford was preparing to publish a volume in conjunction with Dr J.B.D. Stillman entitled *The Horse in Motion*, using reproductions of Muybridge's Palo Alto pictures without his consent. This led to the break-up of their relationship. Muybridge could well have done without the legal battle that ensued. Meanwhile, *The Attitudes of Animals in Motion*, Muybridge's own offering, was receiving greater acclaim than its rival.

The lecture tours had gone well and Muybridge was already formulating plans to photograph animals, birds, men, women and children in a variety of actions, but without Stanford he would need to look elsewhere for backing. He found it at the University of Pennsylvania, where in 1884 he commenced an exhaustive project that led three years later to the publication of *Animal Locomotion*, comprising 781 plates, each showing multiple exposures of a subject in motion. Over 20,000 photographs were taken. The equipment was more advanced than at Palo Alto. Muybridge had also switched to the quicker dry-gelatin process of exposure. Subscribers to the publication were notable: among them was the inventor Thomas Edison. Artists, too, were influenced by the work: Edgar Degas and, later, Francis Bacon, both drew inspiration from some of the human categories of *Animal Locomotion*. At $600, few of the full set were sold, but many of the 100 plate sets were purchased. Several volumes of twenty specimen plates also survive.

The years between *Animal Locomotion* and the World's Columbian Exposition in Chicago in 1893 were taken up with more lecture tours. In 1892 Muybridge prepared his contribution to the Chicago Exposition — a dedicated building called a Zoopraxographical Hall, at which he would show the zoopraxiscope,

now with colour-painted images based on his photographic sequences, but with the distinct flavour of animation as opposed to photographic projection. Many of these later discs are enhanced by imaginative backgrounds. The effect on the screen was similar to that of a 'realistic' cartoon. Yet Chicago's tastes proved too 'popular' for Muybridge. In the age of Edison's 'Kinetoscope' and the development of celluloid film, Muybridge put the experience behind him, later stating that he wanted to be remembered for the pioneering and influential analytical work of the 1870s and 1880s.

In the last years of his life, Muybridge concentrated on lecture tours and came back to England more often, eventually settling in Kingston, the town of his birth, in the late 1890s. In 1899 he published *Animals in Motion*, a retrospective of his work of 1872–85. In 1900, *The Human Figure in Motion* was published, using over 100 plates from the Philadelphia years. Muybridge would not associate himself with the movie-making industry. Perhaps he felt that it was mere entertainment and that analytical photography was academically more significant. His influence on those movie-makers, particularly on Edison, is well documented. Muybridge knew that however limited the zoopraxiscope had been, the effects of its first projections were profound.

Nobody knows how Muybridge's often painful life had affected him, particularly in later years. He never spoke to anyone about it. He died in 1904, a grand and accomplished man, alone with his thoughts in the garden of 2 Liverpool Road, Kingston upon Thames, surrounded by a half-completed scale model of the Great Lakes of North America, one of his few unfinished projects.

Loading River Steamer, New Orleans, c.1859. Some doubt exists as to whether Muybridge took this image, but it is amongst his own collection of slides. He later recalled in a letter the time he spent watching vessels being loaded in the Louisiana town. The different positions of the men as they walk up and down the gangplank is evidence of a carefully timed photograph; its fascination with movement also betrays the identity of the photographer.

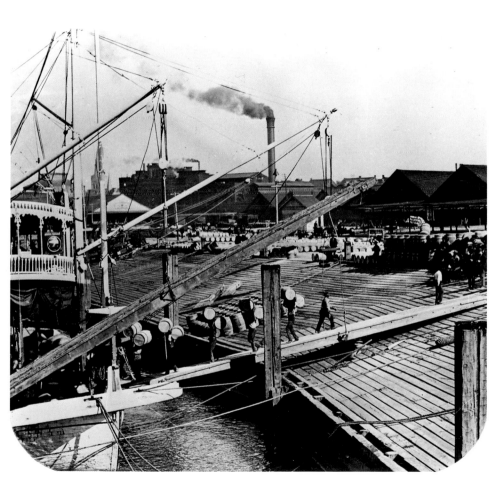

The Flying Studio, Yosemite Valley, 1867. Muybridge spent much time photograph-
ing the scenery of the Yosemite Valley, working under the pseudonym Helios. The
name can be seen on one of the boxes in the foreground and scratched on the
negative at the bottom right of the picture. This photograph shows the extent to
which a Victorian photographer was his own chemist. The journeys up the valley
were dangerous and the equipment had to be handled carefully.

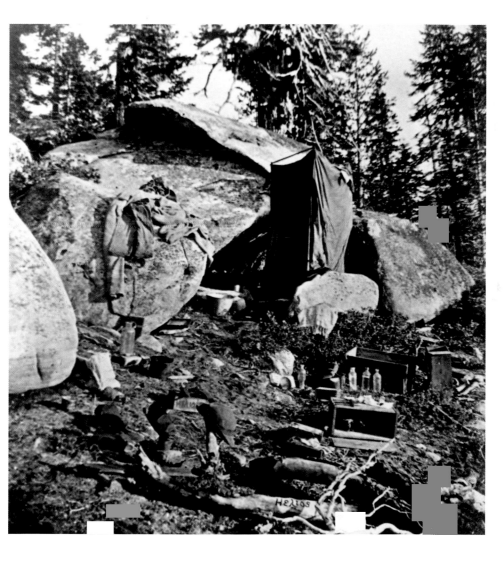

Atlantic City, New Jersey – a Loving Couple, c.1860s. Personal images are rare for Muybridge, and his reason for choosing this touching subject is not known. The photographer had his own brush with love whilst living in San Francisco in the 1870s, when he married a young divorcee who subsequently had a public affair with another Englishman, Harry Larkyns. The consequences were to cost the lover his life. Muybridge, who shot him, starred in a celebrated murder trial in 1875, at which he was famously acquitted.

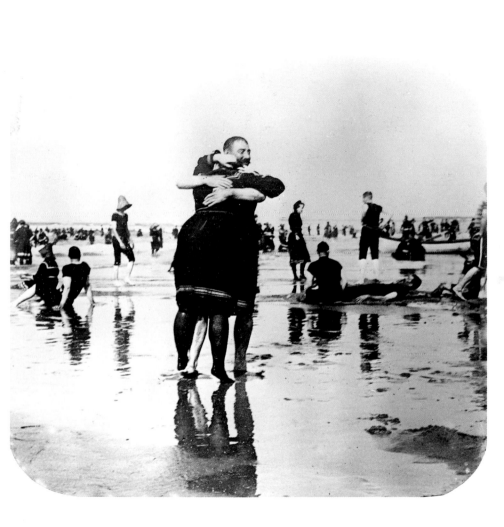

Yellowstone Park, Middle Geyser Basin, Hell's Half Acre, c.1868. Of Muybridge's many photographs of Yellowstone Park, this picture showing the Yellowstone National Mail Transportation Coach carries a particular symbolism. In 1860, Muybridge had suffered a serious accident whilst riding in the Butterfield Overland Mail Company Coach through Texas, destined for the East Coast. He was thrown from the vehicle after the team of four horses ran wild, the driver losing control. The coach overturned, killing one of his fellow passengers, and Muybridge dashed his head against a rock. Hours went by before the company's scouts were sent out to help.

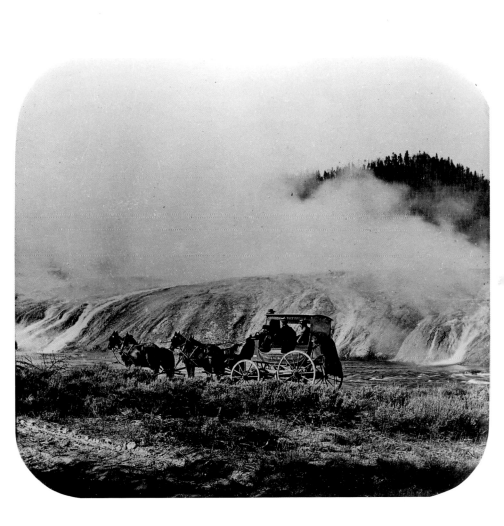

Rocks and Ship at Sea by Moonlight, Alaska, c.1868. This picture was probably taken by Muybridge on his trip to Alaska for the American government in 1868. It displays his fascination with altering the mood of a scene by using a cloud study from another negative and accentuating the 'moon'.

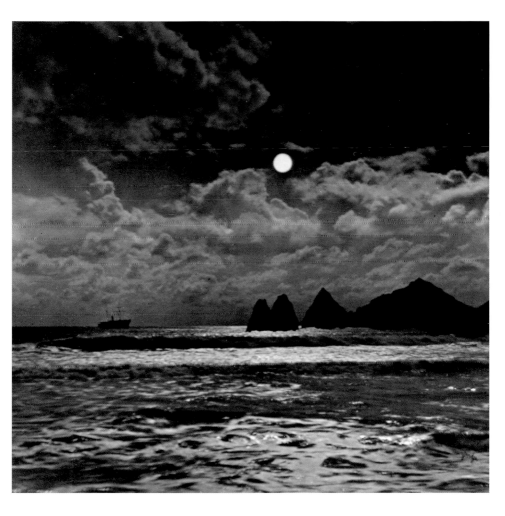

Indian Village, Tongass, Alaska, 1868. Government commissions greatly enhanced Muybridge's growing reputation. In 1868 he accompanied General H.M. Halleck to Alaska to help him survey the US government's newly acquired territory, specifically the military posts and harbours. Bought by Secretary of State William H. Seward from Russia for $7.2 million, the land known popularly as 'Icebergia' or 'Seward's Folly' proved rewarding for Muybridge. From Sitka, the centre for American operations in Alaska, Muybridge took pictures that have passed into social rather than military history. Muybridge said of the natives 'the Indians are well advanced in the industrial arts, some of them, such as the Tongass, being polished and educated'.

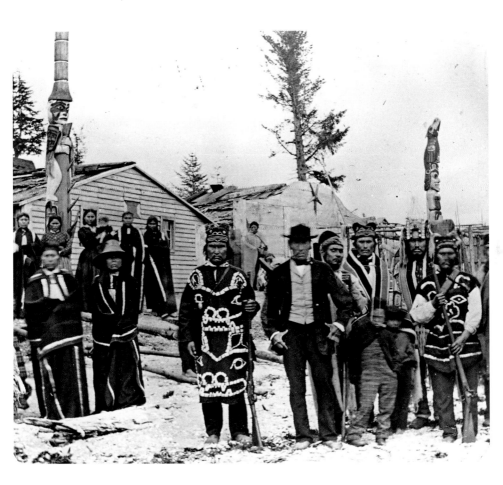

Pile of Buffalo Skulls, Chaplin Station, Canada, British Columbia, 1868. On his way to photograph Alaska for the American government, Muybridge visited British Columbia and photographed scenery at Victoria, Esquimault and Nanimo on Vancouver Island. His photographs were not without some historical documentary significance. This picture, taken at Chaplin Station, shows an extraordinary number of buffalo skulls piled so high that the mound has suffered a minor landslide.

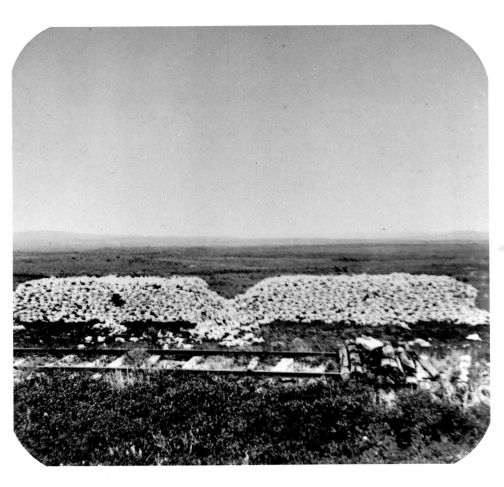

House at Haywoods after Earthquake, San Francisco, 21 October 1868. In San Francisco, opportunities often presented themselves for earthquake photographs. This picture shows the frailty of the buildings in the city at the time, foretelling the kind of damage that would occur on a grand scale in 1906, when most of the city was destroyed. Muybridge was, however, to capture the pre-earthquake landscape of the town in a thirteen-panel panoramic view in 1877 and 1878.

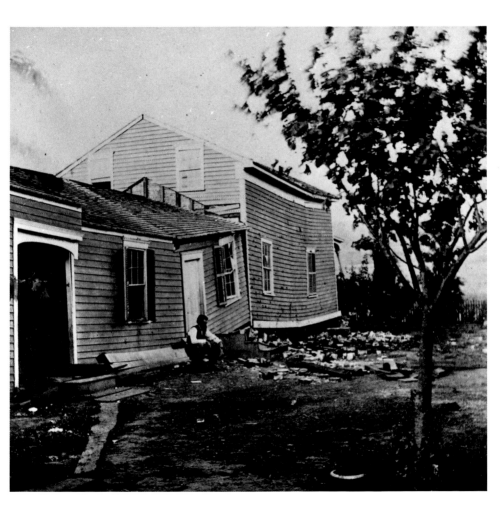

Woodward's Gardens 'by Moonlight', San Francisco, c.1870. The gardens were a famous resort for the townspeople of San Francisco, providing a focus for culture seekers. Attractions included a menagerie, a rotary boat ride (bottom right of the picture with Muybridge's pseudonym, Helios, inscribed on a sail), side-shows, a conservatory and an art gallery at which Muybridge exhibited. The moon hole made in the negative is extremely clear; less obvious, however, is the device known as 'Sky Shade', which Muybridge himself patented. This involved the holding back of the sky area of the negative during exposure to allow for the introduction of another, separate cloud study.

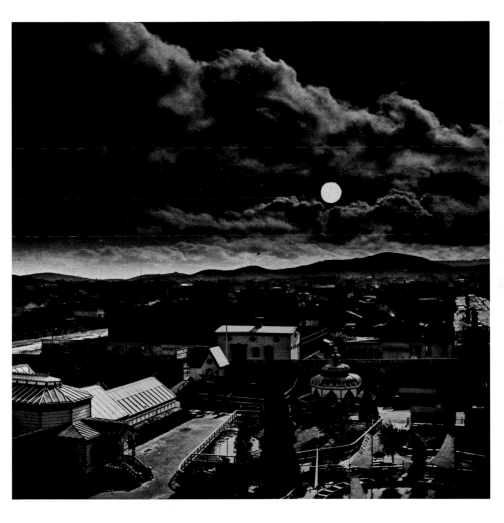

Chang Woo Gow, 8 ft 3 in High and His Wife, San Francisco, c.1870. Among the attractions at Woodward's Gardens in San Francisco was the giant Chinaman Chang Woo Gow, whose presence could hardly have gone unnoticed. Muybridge took many pictures in and around the gardens, including one of himself 'asleep' in front of the paintings in the main art gallery in the park.

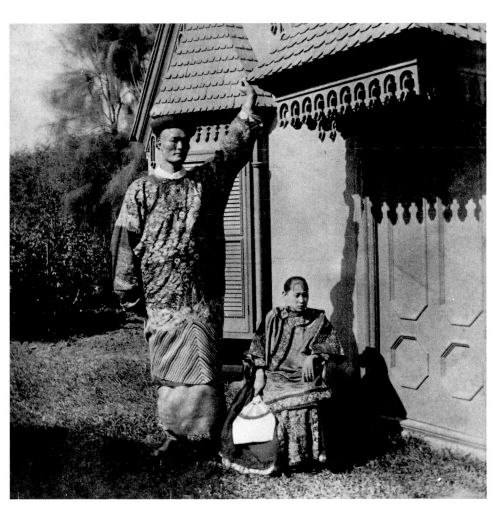

Cathedral Rocks — a View of the Valley, Yosemite, 1872. Muybridge brought his own style to Yosemite Valley photography. He was not the first on the scene, being preceded by Carleton Watkins and Charles L. Weed, yet his work was distinctive. This picture shows Muybridge's compositional skills. The winding river provides perspective, whilst the tree on the right and cliffs on the left give a compositional frame for the picture reminiscent of landscape paintings of previous eras. Particular attention is paid to the texture of the twisted tree stump at the bottom right of the picture.

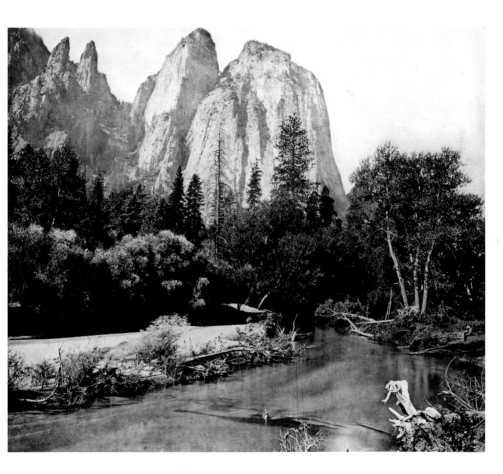

Muybridge on Contemplation Rock, Glacier Point, Yosemite Valley, 1872. The trips Muybridge made to Yosemite Valley in the 1870s involved a huge amount of effort. He was notorious for getting into reckless situations to procure a good photograph. This photograph was used in evidence for the defence at his murder trial in 1875 to demonstrate his mental instability.

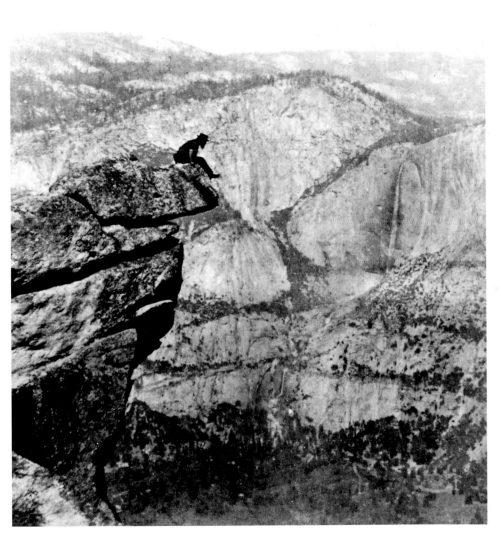

Pi-Wi-Ack (Shower of Stars), Yosemite Valley, 1872. This is an example of Muybridge's attention to detail in his landscape work. Here, the main focus of interest is the running water, which provides a perspective for the viewer. The texture of the foreground rocks is also a dominant element in the picture. The tree overhanging the waterfall was subsequently touched-out by Muybridge to make for a less cluttered skyline.

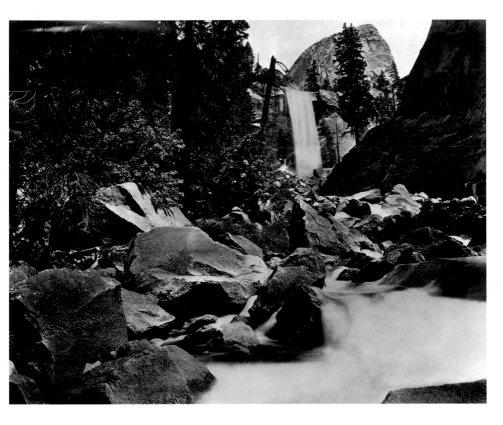

Generals Jeff C. Davis, Hardie, Gillem and Officers of the Modoc Campaign, The Modoc War, 1872. In 1872 the Modoc Native Americans of northern California were clinging to their territory in the face of an onslaught by the US Army. Working for the Bradley and Rulofson gallery on behalf of the government, Muybridge photographed the lava beds, the traditional hunting grounds of the Modocs prior to their expulsion. The Modocs had some famous successes before their demise. Notable amongst these was a surprise ambush of Colonel Frank Wheaton's troop of 400 men in a pass. However, despite their better knowledge of the terrain – the very ground that Muybridge had been sent to photograph – the end was extremely brutal for the Modocs.

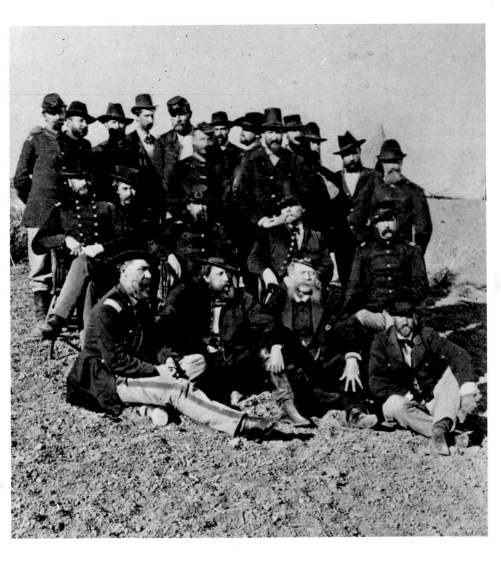

Toby (the Squaw who Warned General Canby of his Impending Fate), and Four Old Modoc Squaws, The Modoc War, 1872. Although sent to photograph the terrain and not the fighting of the campaign, Muybridge did find some characters of the war to photograph. Here is a direct reference to the notorious murder of General Canby by the Native American chief Captain Jack, which took place at a truce meeting and sparked the retaliation of the US Army. Pictured here is the squaw (centre, rear) who informed the general of the impending treachery.

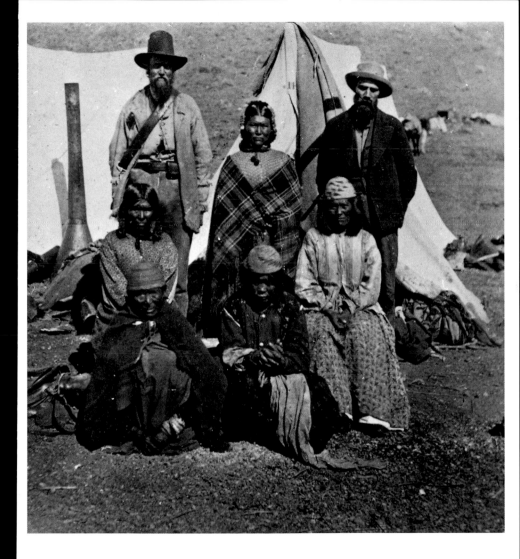

Quadruple Track Tanks, Central Pacific Railroad, Monmouth, c.1873. The CPRR company was comprised of the famous 'Big Four' Railroad barons: Collis P. Huntington, Mark Hopkins, Governor Leland Stanford and Charles Crocker. Muybridge was commissioned to photograph the Central Pacific Railroad, which was to join up with the Union Pacific Railroad. Work began on track-laying eastwards from Sacramento in 1863. The CPRR and the UPRR met in 1869 in Utah, the former having completed 1,776 miles of track across difficult terrain.

Destroyed by Earthquake 1744, Ruins of the Church of El Carmen, Antigua, Guatemala, 1875. After the ordeal of his trial for the murder of Harry Larkyns, Muybridge travelled to Central America and concentrated his skills upon what became an exquisite volume entitled *The Pacific Coast of Central America and Mexico; the Isthmus of Panama; Guatemala; and the Cultivation and Shipment of Coffee*. He was in Guatemala for six months and took over 400 pictures. Ruined churches of the Spanish Colonial period were a particular favourite.

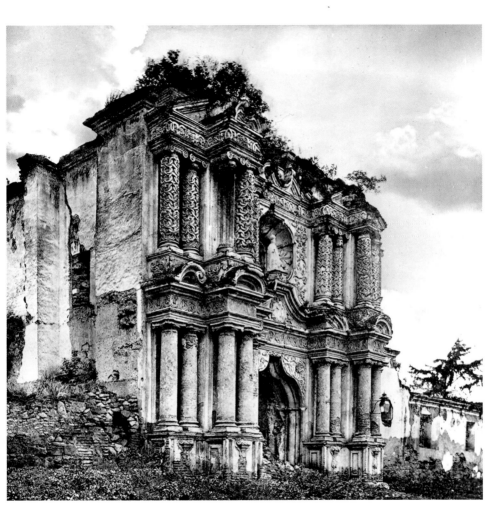

Panorama of San Francisco from California Street Hill, No. 1, 1878. The Mark Hopkins residence was an extraordinary building, commanding an amazing view of San Francisco. Throughout the 1860s and 1870s, Muybridge had produced some understated efforts at panoramic views of the city. In January 1877, he set himself up in the Hopkins Tower, using 8 x 10 inch plates, producing a panorama of eleven panels measuring 7 feet in length. Later that year, he issued it from Morse's Gallery in Montgomery Street for a price of $10. Accompanied by a key of the individual buildings, it became a collector's item.

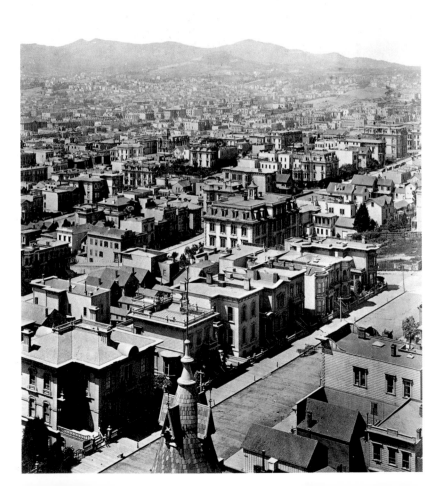

Panorama of San Francisco from California Street Hill, No. 2, 1878. Unsatisfied with the eleven-panel version of the panorama, Muybridge returned to the Hopkins Tower in November with a new set of equipment and, using 18 x 22 inch plates, produced a huge version of the panorama measuring 17 feet in length, comprising thirteen panels of 20 x 16 inches. Sadly, a fire at Morse's Gallery consumed the negatives of the 1877 panorama and all of the negatives from his trip to South America. In April 1878, Muybridge set out again to climb the tower on Nob Hill and took a panorama of breathtaking quality on mammoth plates as he had done before. The 1878 panorama survives today in nine separate copies around the world.

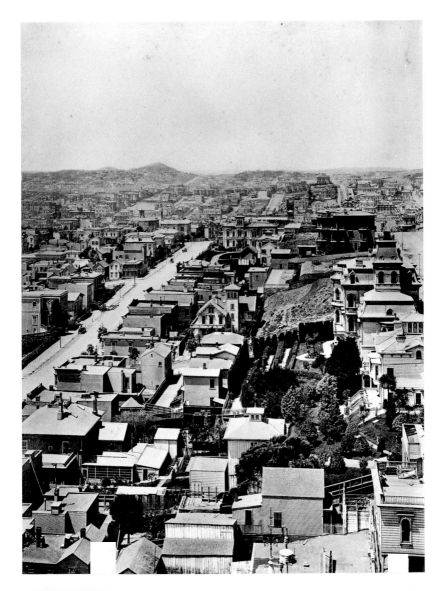

Panorama of San Francisco from California Street Hill, No. 3, 1878. One of the most remarkable stories in Californian social history is included in this third picture of the giant 1878 panorama. Nob Hill was the wealthy area of the city. Charles Crocker owned the huge residence towards the rear of the picture. Nicholas Yung owned a modest house nearby. Crocker wanted Yung to sell him his house so that he would have more land. Yung refused to sell and the result was the famous 'spite fence', which Crocker built on three sides of Yung's house to spoil his view. It was so high that Yung could only see out on to the street. The fence is partially concealed by the large white building, but the chimneys of Yung's house are visible.

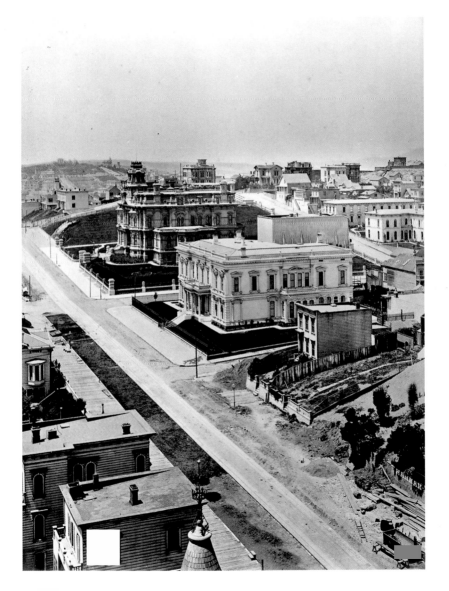

Panorama of San Francisco from California Street Hill, No. 4, 1878. Muybridge's experiences with previous panoramas taken from the same position in the Hopkins Tower in 1877 had taught him that he had to take each segment so that there were no overlaps. Using a 40-inch near-telephoto lens, he was able to divide the 1878 attempt into thirteen, rather than the usual eleven, plates. This plate shows California Street Hill, the Golden Gate, Russian Hill and Richardson Bay.

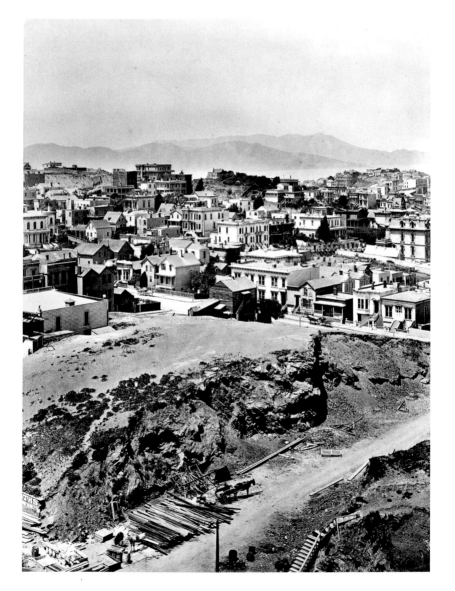

Panorama of San Francisco from California Street Hill, No. 5, 1878. Muybridge is thought to have started work at about 11 a.m., with the help of an assistant, taking each of the panels in sequence. The shooting did not finish until four in the afternoon. The position of his equipment was carefully marked out on the floor of the tower for each shot. In this fifth panel, Alcatraz Island is clearly visible. In the foreground are the weather-boarded buildings that were not to survive the catastrophic earthquake of 1906.

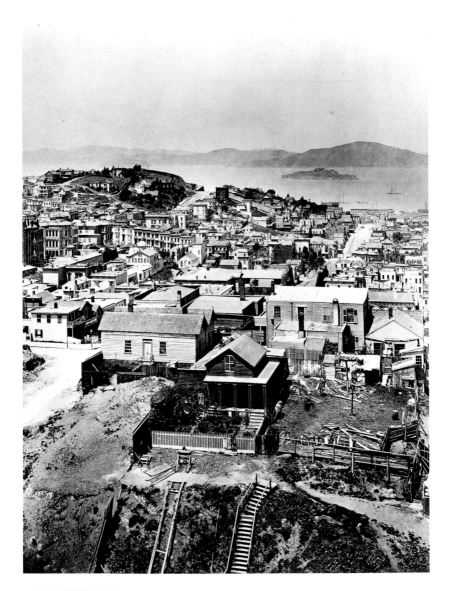

Panorama of San Francisco from California Street Hill, No. 6, 1878. The main road visible here is Powell Street. Powell and Mason represent the second of four compositional triangles in the panorama formed by the effects of the principal roads as they disappear towards the horizon. This would have helped viewers of the panorama orientate themselves in the overall scheme of things. Since the panorama functioned as a focus for civic pride, compositional detail was an important aspect of the work.

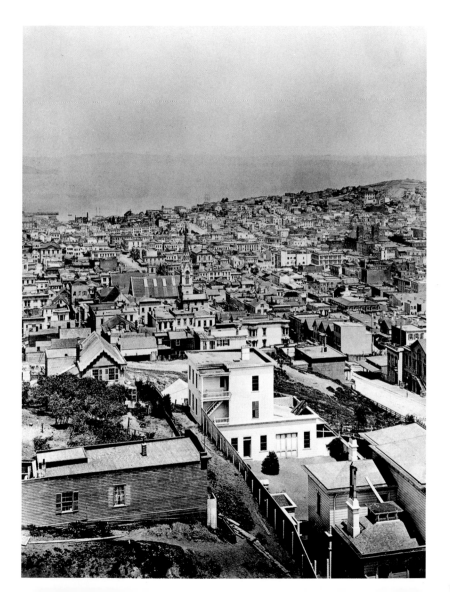

Panorama of San Francisco from California Street Hill, No. 7, 1878. Although Muybridge is known to have exposed the panorama in the order in which the plates are presented, he clearly came across a problem on plate number 7, which must have been damaged or appeared unsatisfactory in some way. Painstakingly, the photographer set his equipment up again later in the day in the same place and retook the picture. Despite the near perfect joins at the edges, the print is revealed as a later retake by the length of the shadows, particularly that of the chimney in the foreground.

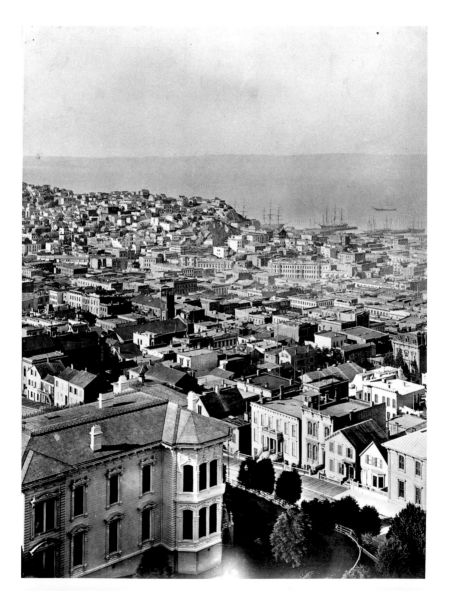

Panorama of San Francisco from California Street Hill, No. 8, 1878. Until Muybridge attempted his panorama of the city, most previous versions simply covered views of 180 degrees or less. In this panorama, Muybridge undertook an ambitious 360-degree circuit. Here, in plate No. 8, the reappearance of California Street marks the 180-degree point from the start. Clearly visible is the cable-car track in the road, which was laid down between July and November 1877.

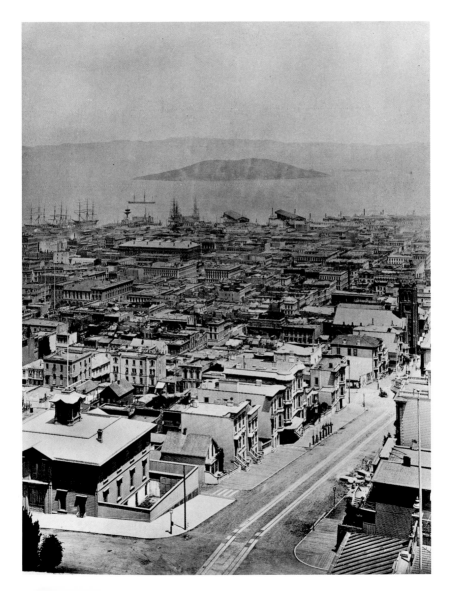

Panorama of San Francisco from California Street Hill, No. 9, 1878. Close inspection of each panel shows a depth and quality to the exposures that reminds us that Muybridge, although working in the wet-collodion method, was a master chemist. His fast-exposure experiments rewarded him well in his landscape photographs. Barely visible in the foreground of plate No. 9 is the roof of the Stanford mansion, which was next to the Hopkins residence from which the panorama was taken.

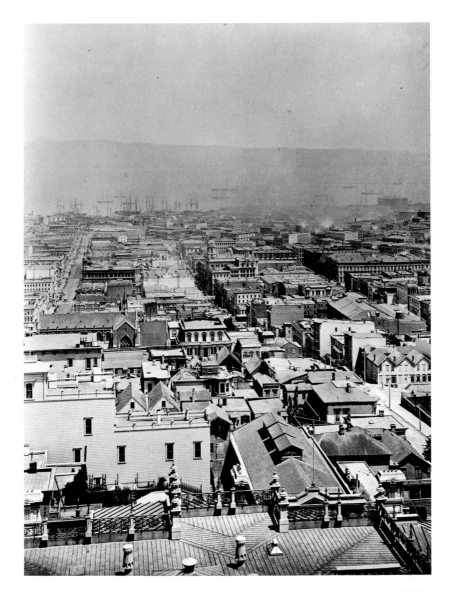

Panorama of San Francisco from California Street Hill, No. 10, 1878. The 1877 prospectus for the panorama reprinted from the *Alta California*, sums up the philosophy of its construction: 'The Photograph of San Francisco, recently made by putting together a succession of views which, taken from a commanding central point, make a complete circuit of the horizon suggests to us that among the many wonderful features of our city, the panoramic character of its topography is not the least deserving of its attention, though it has been overlooked, at least by people generally, until Muybridge discovered and utilized its artistic value.'

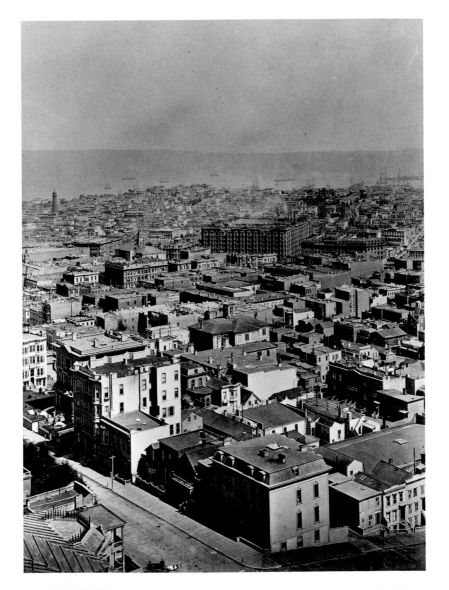

Panorama of San Francisco from California Street Hill, No. 11, 1878. An unusual metaphor was used, presumably with Muybridge's approval, in the prospectus for the 1877 panorama: 'Let us imagine a small ant wishing to get a comprehensive view of a painted Japanese dinner-plate. He would succeed if he could get a thimble upright in the middle of the plate, then climb to the top of the thimble and look by turn in every direction. The ant, in that hypothesis, occupies a position similar to that of the man in San Francisco, which represents the saucer, and the palatial dwelling of Mrs. Mark Hopkins, on California Street Hill, is the thimble. The rim of the saucer is furnished by various ridges and spurs of the Coast Range, varying in height from 300 to 3,800 feet.'

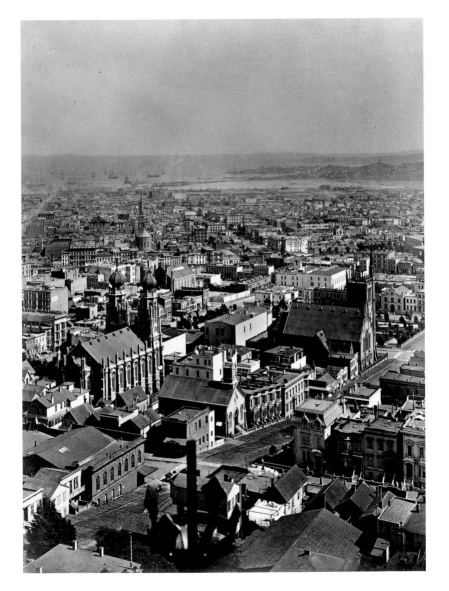

Panorama of San Francisco from California Street Hill, No. 12, 1878. The 1877 and 1878 large-plate versions of the panorama were far more prestigious than their eleven-panel predecessor, although their asking price is not known. Here, plate No.12 shows the US Mint with twin chimneys in the middle distance. Each of the negatives in the work is thought to have taken between thirteen and fifteen minutes to expose, and since they were executed one after the other in order (with the exception of No. 7) the difficulties in handling the huge 18 x 22 inch glass plates so swiftly must have been immense.

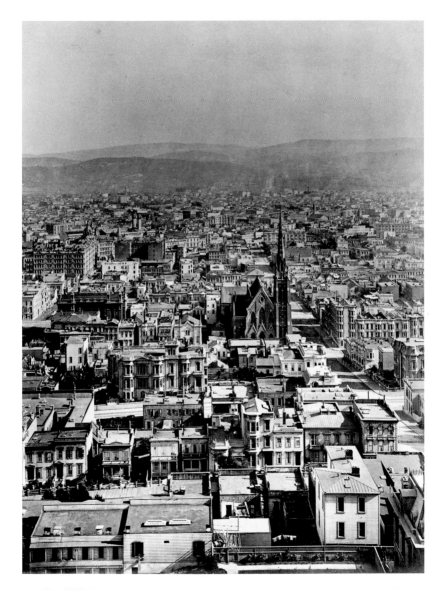

Panorama of San Francisco from California Street Hill, No. 13, 1878. Completing the 360-degree panorama is a scene showing the San Miguel Hills in the distance and a multitude of private residences and religious buildings. Plate No. 13 represents the completion of the circuit of the city in its entirety, projecting a rare image of San Francisco, which appealed to the culture-hungry citizens. Next to the domed Hall of Records is Woodward's Gardens, where Muybridge was based in the 1860s.

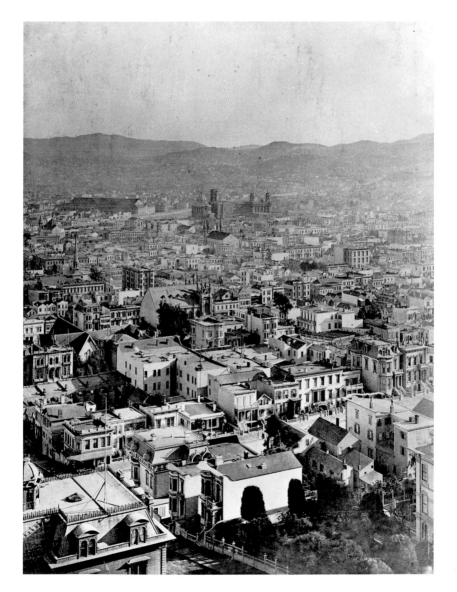

Governor Leland Stanford, c.1877. This lantern slide was used by Muybridge in his 1881 lectures on Animal Locomotion. Leland Stanford, Governor of California and President of the Central Pacific Railroad, was a tireless worker. He was also a millionaire. He lived in an extraordinary mansion on Nob Hill in San Francisco, alongside the other railroad barons. Muybridge's moving-image work would not have happened without Stanford's financial backing.

Abe Edgington, Made on a Wet Collodion Plate, Palo Alto, California, 1877. This is one of the earliest pictures from the Palo Alto Series experiments, showing Governor Stanford's horse Abe Edgington walking. The lantern-slide original from which the picture is taken is marked by the photographer and indicates that the picture had been taken on a wet-collodion plate. Muybridge, through constant chemical experiments, was able to produce rapid exposures on what was becoming an outdated technology. It was some years before he moved to the popular dry-gelatin process.

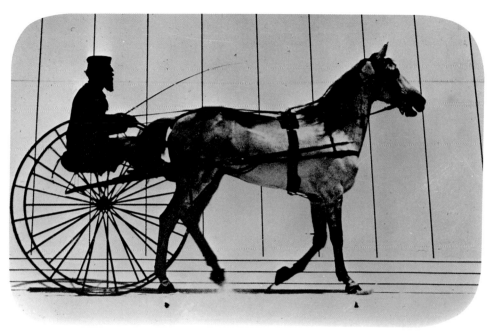

Palo Alto Stock Farm, California, late 1870s. Governor Leland Stanford was a passionate lover of fast horses, but until 1876 he did not have a breeding farm. In that year, he bought Mayfield Grange, a farm building at Palo Alto about thirty miles south of San Francisco. Stanford's desire to breed a better racer led him and Muybridge to conduct the famous analytical photographic experiments at the race track on the farm between 1877–81. The results were to change the history of photography for ever.

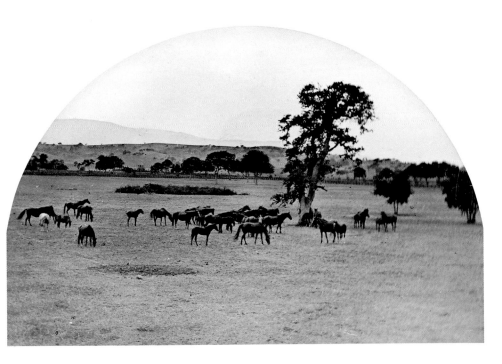

The Experimental Camera Shed at Palo Alto, California, 1877–9. This photograph was used in Muybridge's international lectures and printed in his 1881 publication *The Attitudes of Animals in Motion*. After asking Muybridge to solve the question of whether a trotting horse had all four feet off the ground at any one stage of its movement, Governor Stanford asked Muybridge to consider in detail the way in which his horses moved. In a change from the earlier single-exposure experiments of 1872, Muybridge used the help of the Central Pacific Railroad engineers to build a camera shed containing a row of twelve (later twenty-four) cameras. The most successful pictures were taken with an electromagnetic timer mechanism, which released the shutters in front of the cameras.

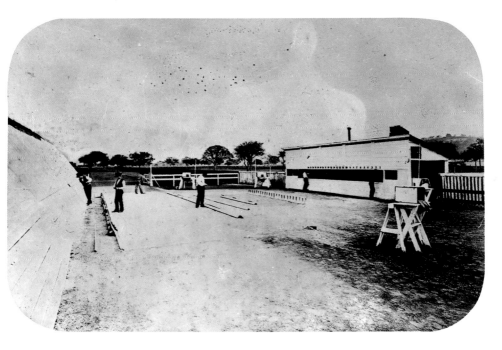

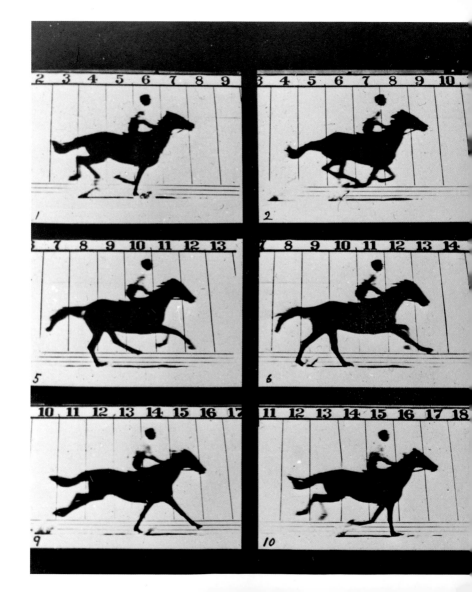

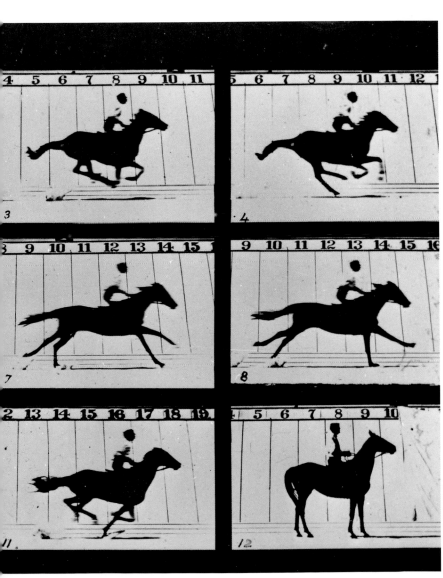

(previous page) Sallie Gardner Galloping, Palo Alto, California, 1878. The experiments at Palo Alto were impressive in their results. This picture, reproduced in *The Attitudes of Animals in Motion* in 1881 and used for lectures, shows the sequences of the galloping horse Sallie Gardner. It also shows that Muybridge's sequences were sometimes contrived, although based on actual phases of movement. The last picture in this sequence is unlikely to follow directly from the one preceding it, since the horse is at an absolute standstill just a fraction of a second after being at full gallop.

Occident Trotting, Palo Alto, California, 1878. In 1872 Governor Stanford's horse Occident, a famous Californian trotter, had been the subject of the first photograph to prove that a trotting horse had all four feet off the ground at one stage of its movement. More pictures were taken in 1876 and 1877 of the same horse trotting with a sulky and driver. The original pictures from these earliest experiments are lost to us, but this picture, taken at Palo Alto, ranks as the earliest surviving picture. The horizontal lines at the base of the backdrop are four inches apart.

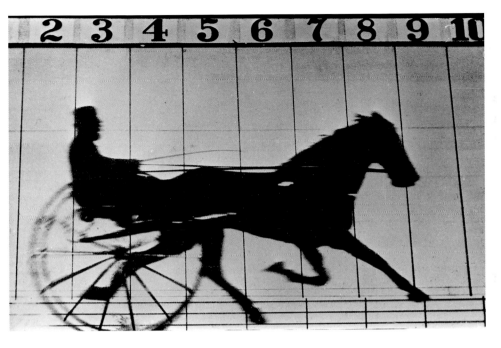

Electro-Magnetic Timer Mechanism, 1878–80. This was another of Muybridge's photographs to be used as an important part of his lectures in explaining his technical achievements. Muybridge's attempts to take an instantaneous photograph of a moving subject went through several phases at Palo Alto. At first, a horse would break successive strings attached to the camera shutters in the shed as it passed them. This had limited success. Then, when taking pictures of a horse with a sulky and driver, electromagnets were attached to the shutters. When the wheels of the sulky passed over wires laid on the ground, a circuit was completed and the shutters would fall. Eventually, a timer mechanism was devised, which set the shutters off in sequence automatically, without the subject having to take its own picture.

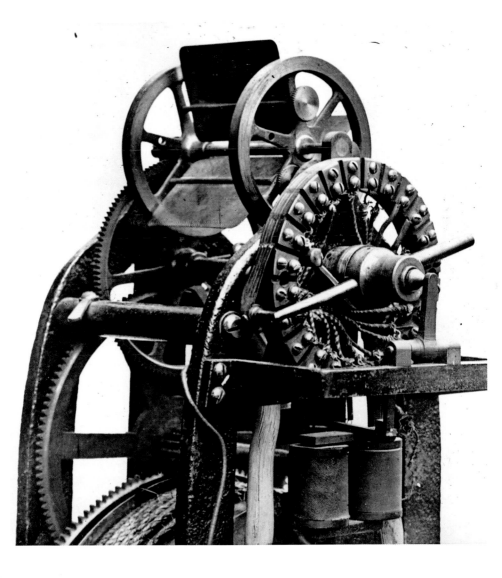

The Camera Shutters From the Palo Alto Experiments, 1878–9. By 1878, Muybridge, with the help of engineers from the Central Pacific Railroad Company, had mastered the method by which the electromagnets holding the shutters in place could be released on a timer mechanism as the subject passed in front of the bank of cameras in the shed. Once tripped, the two shutters, which had been held under pressure by India rubber springs, passed each other at high speed, exposing an area of just two inches for an estimated 2000th of a second. This picture shows the shutters in position before, during and after the subject has passed the cameras. Muybridge was so proud of his technical achievements that he photographed his equipment and published these images alongside the results of his scientific experiments.

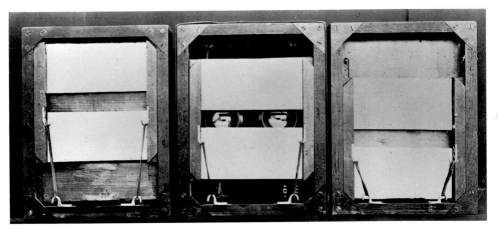

Gymnasts from the Olympic Club of San Francisco, Palo Alto Series Print, 1879. This picture appeared as the 123rd illustration in the volume chronicling Muybridge's Palo Alto work entitled *The Attitudes of Animals in Motion* (1881). It dates from August 1879, when Muybridge began taking photographs of humans in motion. The photographer is pictured in one of the shots, shaking hands with the strong man, L. Brandt.

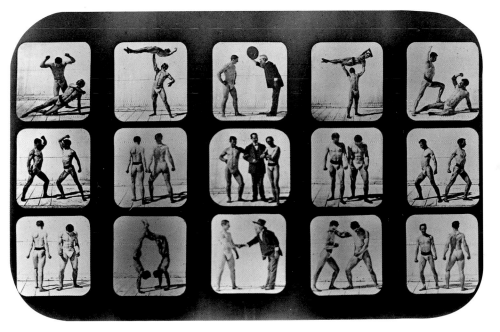

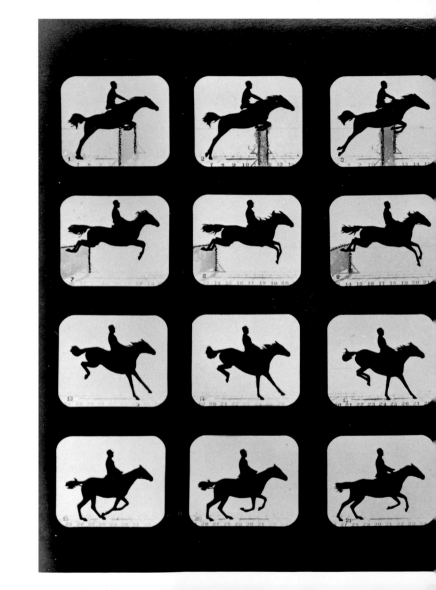

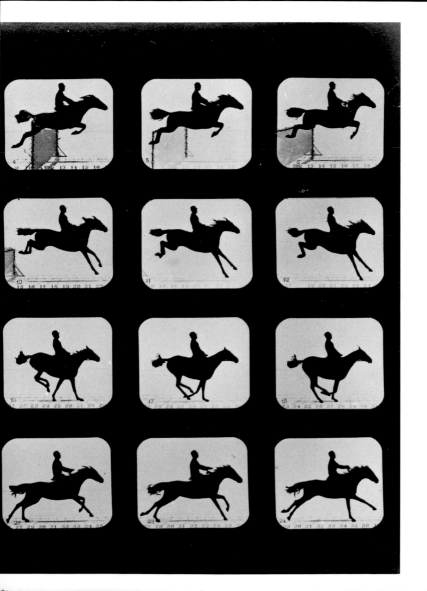

(previous page) Horse Jumping, Palo Alto Series Print, 1879. Taken in 1879 when Muybridge had switched from twelve to twenty-four cameras in his shed, this photograph shows the attention to detail of the main subject matter: the motion of a horse jumping. Subsequent retouching of the twenty-four original plates that went to make this final offering has produced a faded fence and enhanced animal silhouette.

Dog Running, Palo Alto Series Print, 1878–9. Muybridge's interests extended beyond equine motion, even as early as 1879. The Palo Alto series included sequential images of dogs, cats and birds as well as Governor Stanford's horses.

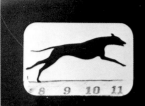

8 9 10 11

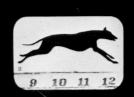

9 10 11 12

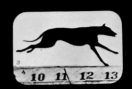

10 11 12 13

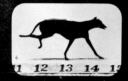

11 12 13 14 15

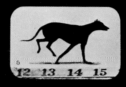

12 13 14 15

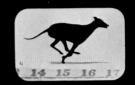

14 15 16 17

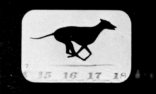

15 16 17 18

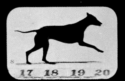

17 18 19 20

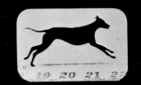

19 20 21 22

The Zoopraxiscope, c.1880. This slide was used at talks on animal locomotion. In 1879, at Mayfield Grange, Palo Alto, in front of a specially selected audience, Muybridge and Governor Stanford put on a show with what can be called the world's first movie projector, in which photography was the original means of capturing motion in real time. Despite its limitations – the short sequences on circular glass discs and the distortion problems caused by a counter-rotating slotted shutter – the zoopraxiscope impressed its audiences over the years, projecting moving photographic silhouettes, sometimes life-size, on huge screens. At first, the machine was used to demonstrate the sequences shot at the Palo Alto experiments. Later, it became a vehicle for colour animations based on photographic sequences.

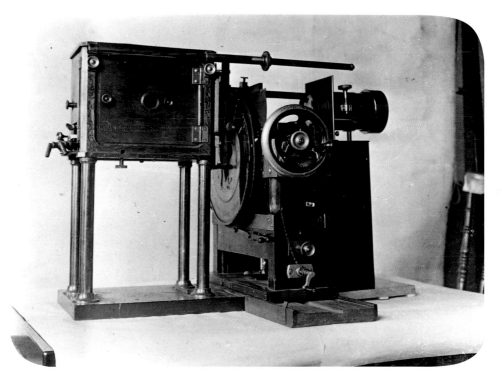

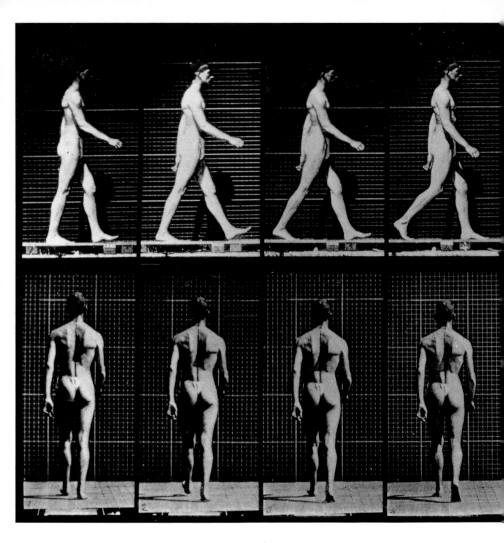

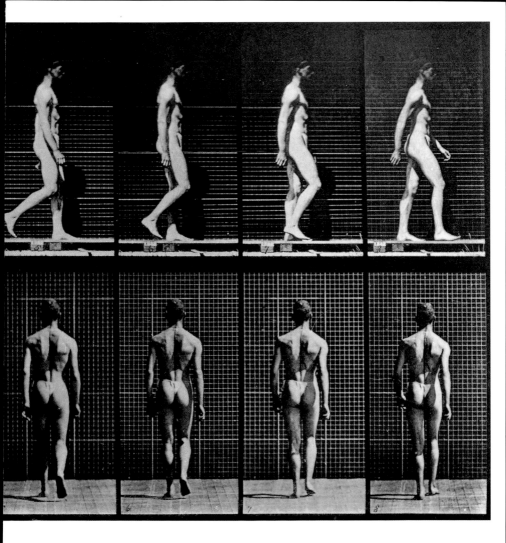

(previous page) Males (Pelvis cloth), Walking, Humans, *Animal Locomotion*, Plate No. 8, 1884–5. The Palo Alto Series of 1877–9 had awakened an unquenchable desire to investigate all aspects of human and animal locomotion. Muybridge secured a position at the University of Pennsylvania at Philadelphia, where he took over 20,000 photographs of people, animals and birds.

Males (Nude), Walking, Humans, *Animal Locomotion*, Plate No. 11, 1884–5. The categories of photographs were varied during the Philadelphia years. Humans were sometimes depicted nude, so that artists and scientists could examine muscle tone and movement during strides. Muybridge, however, did not lose sight of the appeal of nudity in the sales of the work.

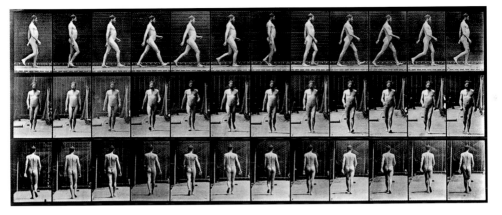

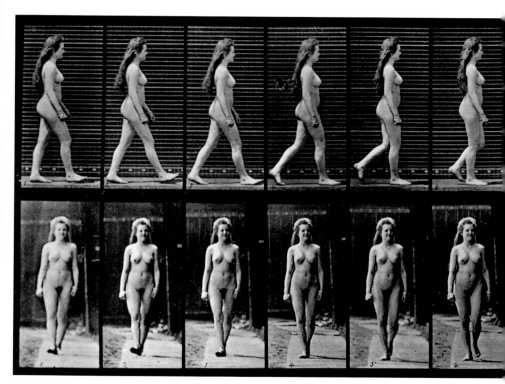

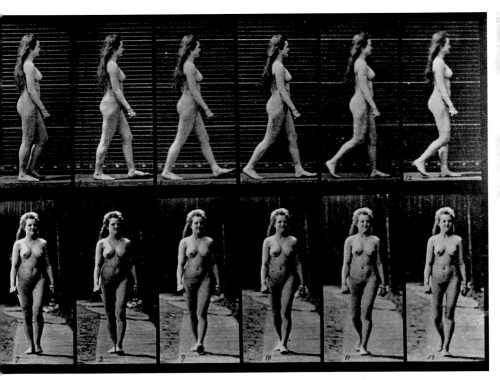

(previous page) Females (Nude), Walking, Humans, *Animal Locomotion*, Plate No. 17, 1884–5. It is sometimes said that there is eroticism in Muybridge's *Animal Locomotion* plates. This may be the case, as he is known to have recruited models from whorehouses in San Francisco. The accusation of voyeurism has always followed the photographer's legend.

Males (Pelvis cloth), Walking, Carrying a 75lb Weight on Left Shoulder, Humans, *Animal Locomotion*, Plate No. 26, 1884–5. The effects of weight-bearing on an individual during movement is a constantly repeating theme within some of the categories of *Animal Locomotion*. As well as a 75lb weight, subjects sometimes carried buckets of water while ascending stairs.

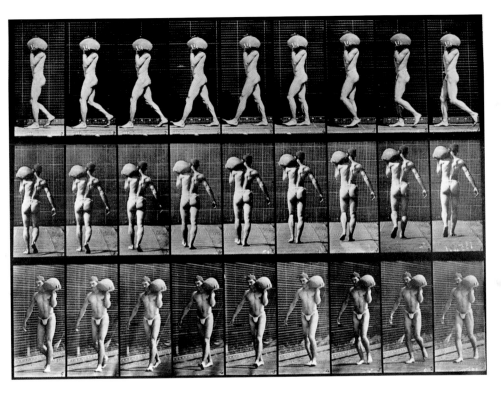

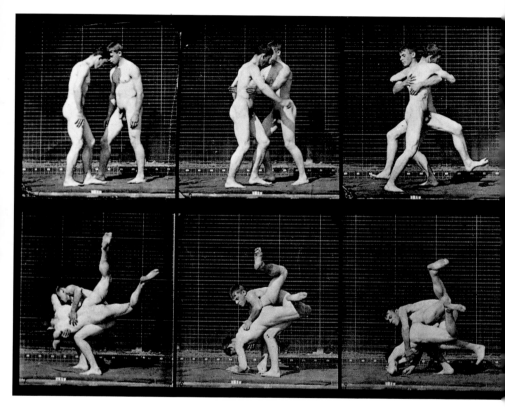

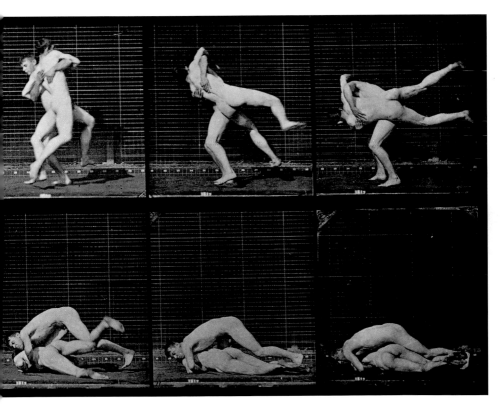

(previous page) Males (Nude), Wrestling, Graeco-Roman, Humans, *Animal Locomotion*, Plate No. 347, 1884–5. Just as the Series Photographs at Palo Alto had attracted attention from artists and scientists alike, so too did the Philadelphia work. This time, the effect was lasting. Among the artists to be influenced by this photograph was Francis Bacon, whose *Two Figures* (1953) was based on the wrestling sequences. This image is one of the bound specimen plates from the presentation portfolio marked 'Author's Edition'.

Females (Semi-nude) & Children, Child Bringing a Bouquet to a Woman, Humans, *Animal Locomotion*, Plate No. 465, 1884–5. The twenty specimen plates that were specially bound and marked by Muybridge for potential subscribers comprise his own selection from the 781 plates of the published work. Muybridge was clearly touched by some of the categories, as this print shows.

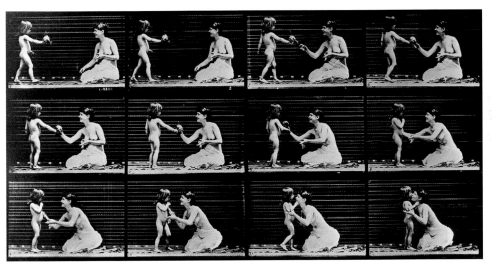

Horses, 'Annie G' Galloping, Animals, *Animal Locomotion*, Plate No. 626, 1884–5. Another favourite of the photographer's Philadelphia years, this print shows that equine motion still preoccupied him, being included among his favourites in this volume for subscribers.

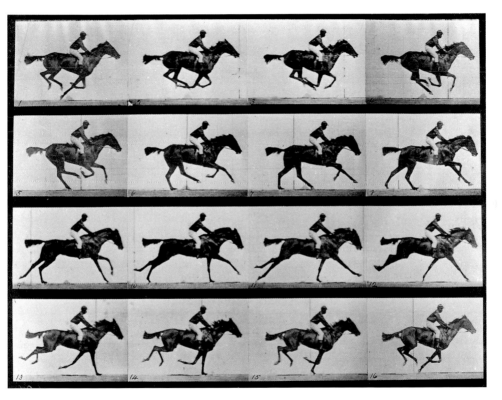

Wild Animals and Birds, Lion Walking, Animals, *Animal Locomotion*, **Plate No. 721, 1884–5**. Photographing George the lion was among the harder tasks undertaken in *Animal Locomotion*. George was restless and separating him from his mate, Princess, was problematic. Success came in the form of this print, which Muybridge was pleased enough with to include in his presentation portfolio.

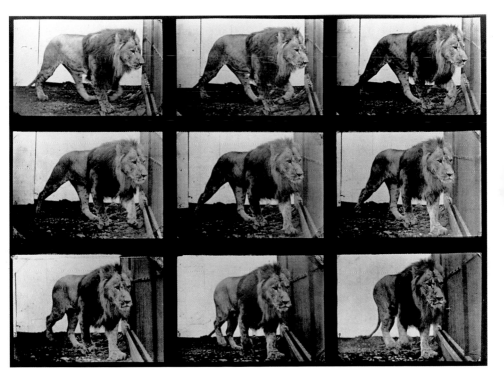

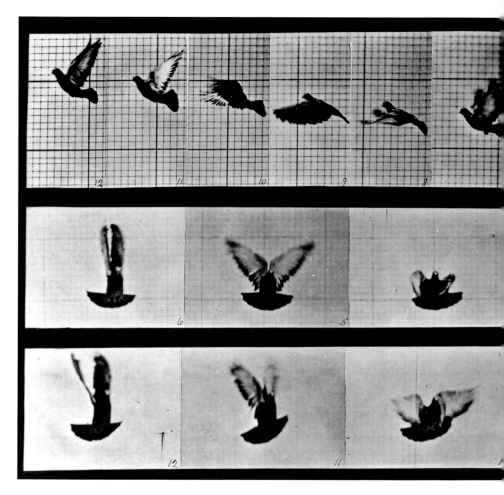

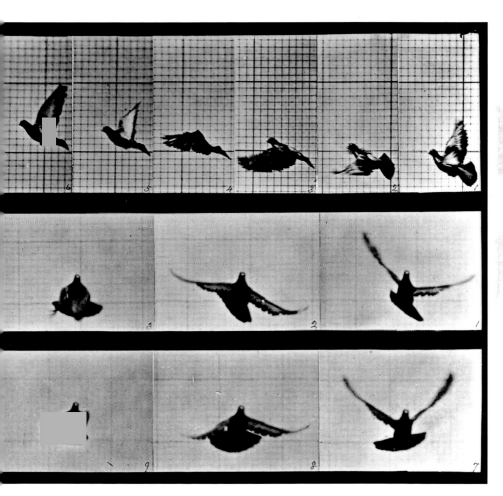

(previous page) Wild Animals and Birds, Pigeon Flying, Animals, *Animal Locomotion*, Plate No. 755, 1884–5. Muybridge's success in photographing birds had attracted the attention of scientists such as Étienne-Jules Marey as early as 1878. During the Philadelphia years, Muybridge had moved from the more old-fashioned wet-plate process to the dry-gelatin process, greatly enhancing the amount of detail in the final print.

Pirouette, 1884–5. This single plate from a multiple print from the *Animal Locomotion* publication has been turned into a lantern slide by Muybridge and may serve to underline the claim that his studies of females in motion were not just restricted to scientific research. There is a deliberately alluring quality to the subject matter.

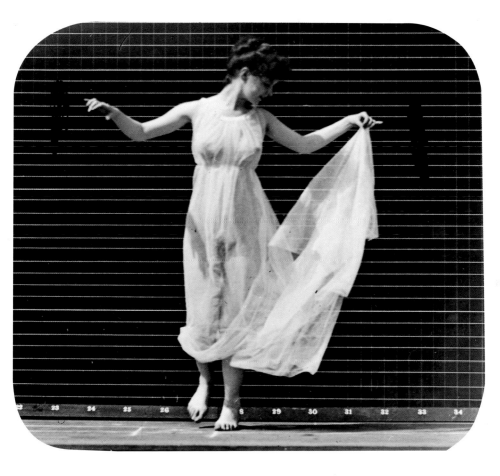

'Gallop', Horse, Bayeux Tapestry, 1880s. Muybridge toured America and Europe in the 1880s, lecturing on the results of his inquiries into animal locomotion. Of particular interest to him in these talks was the inaccurate depiction of equine motion in historical representations. This slide was used in lectures to highlight the misrepresentation of horse movement in the past.

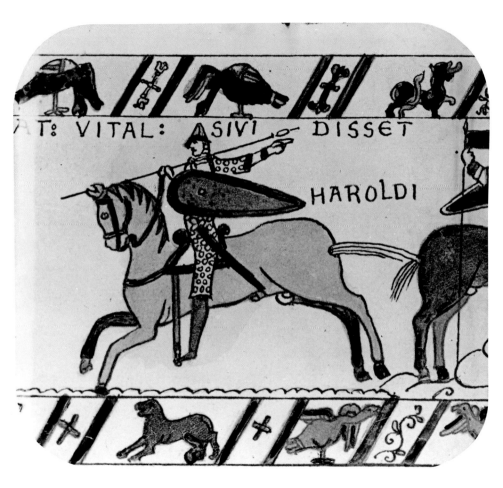

'Gallop', Assyrian, Wall Relief, 1880s. Muybridge went to great lengths when preparing his lecture slides to demonstrate inadequacies in motion depiction. Few cultures were spared his scrutiny as shown by this slide, used in his talk at the Royal Institution in 1882. The point of discussion here was the impossible position of the horse's legs.

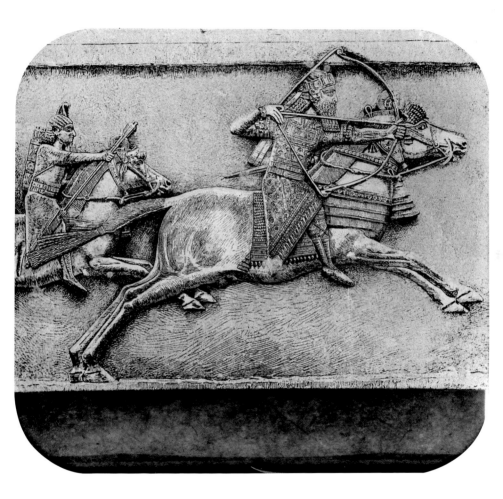

The Ferris Wheel, Midway Plaisance, World's Columbian Exposition in Chicago, 1893. Muybridge exhibited his moving picture projector, the zoopraxiscope, at this famous exhibition and had a hall built especially for the purpose – the Zoopraxographical Hall. The venture was not a great success, however, as most of the images projected were little more than colour animations painted on glass discs, albeit informed by motion photography. After this exposition, Muybridge became disillusioned with the zoopraxiscope and stated that he wanted to be remembered for his sequence pictures – or chronophotographs – of the 1870s and 1880s.

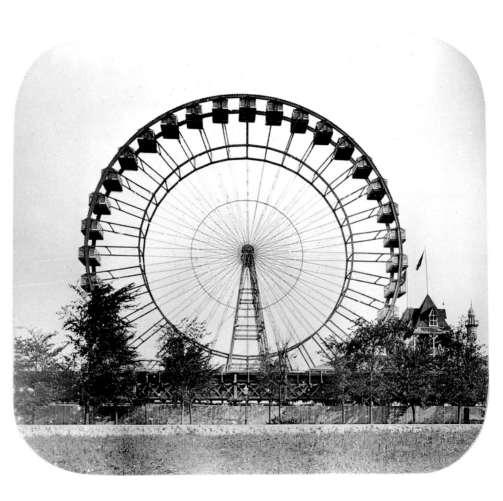

1830 Born Edward James Muggeridge, 9 April, Kingston upon Thames, England, the son of a local coal and timber merchant.

1851 Leaves England to find his fortune in US. Begins career as bookseller in New York.

1855 Moves to San Francisco and continues bookselling.

1860 Makes first of many trips to Yosemite Valley with camera and equipment. In July, suffers serious head injury in a coach crash. Convalesces back in England.

1866 Returns to San Francisco as 'Eadweard Muybridge'.

1867 Begins exhaustive career as landscape photographer. From his 'Flying Studio', he takes hundreds of views of buildings and cityscapes in the city, published under pseudonym 'Helios'. Photographs Yosemite Valley views for John S. Hittel's *Yosemite: Its Wonders and its Beauties*. US government commissions him to photograph Alaska and he makes pictures of Vancouver Island, Esquimault harbour, Sitka and local Tongass natives. Meets Flora Shallcross Stone, whom he later marries.

1869–1871 Government commissions include photographing the lighthouses of the Pacific Coast and the Farallon Islands.

1872–1873 Commissioned to photograph views of the Central, Union and California Pacific Railroads. Produces more views of Yosemite on larger plates (18 x 22 inch negatives). Photographs Governor Stanford's horse, Occident at a Sacramento racetrack, proving a horse does have all four feet off the ground while trotting.

1873 15 April, has a son, Floredo Helios Muybridge. Suspects another man, Harry Larkyns, of being the father and shoots him dead.

1874 Tried for murder in February but acquitted thanks to expert lawyer. Spends rest of the year on photographic tour of Central Latin America. In July, wife dies and his son is put into an orphanage.